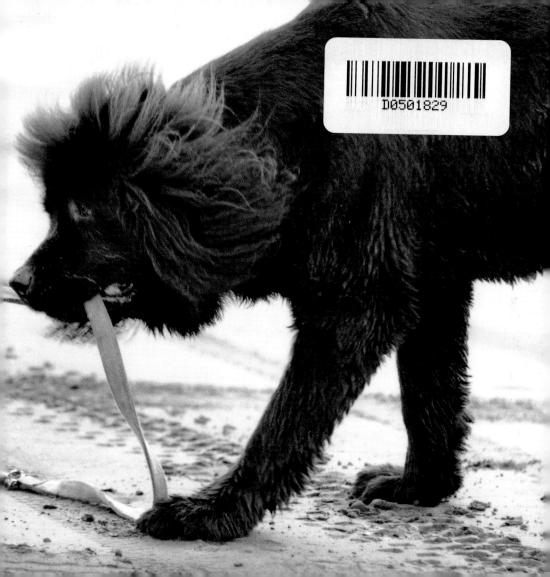

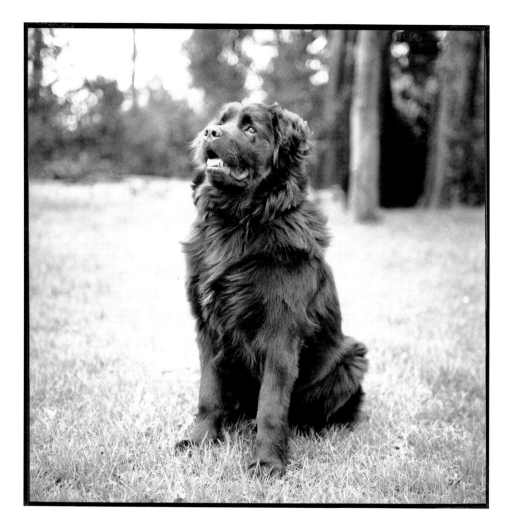

New-found-friends

Rachael Hale

**Andrews McMeel
Publishing**

Kansas City

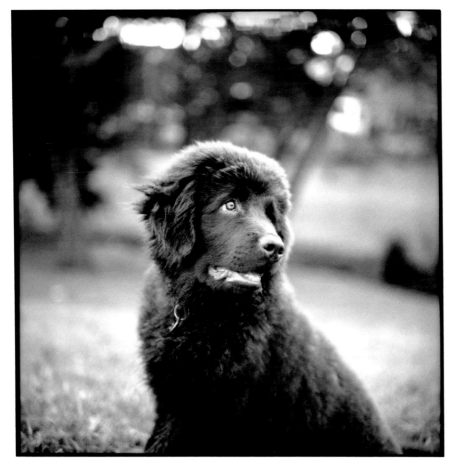

Henry Miller, four months

Henry and I have been "family" now for five years. He is my best friend and through him I have had the pleasure of making many more friends, both Henry's and mine.

Newfoundlands are incredible to work with and a delight to photograph.

Each one's personality shines like a beacon in their expressions and their sense of humor. I hope you enjoy the moments shared in these pages as much as we enjoyed making them.

Rachael

02 03 04 05 06 LEOC 10 9 8 7 6 5 4 3 2 1

ISBN: 0-7407-2718-4

Library of Congress Control Number: 2002103763

Design by Robine Harris

Text by Stephen Prinselaar

Attention: Schools and Businesses

Andrews McMeel books are available at quantity discounts with
bulk purchase for educational, business, or sales promotional use.
For information, please write to:
Special Sales Department, Andrews McMeel Publishing,
4520 Main Street, Kansas City, Missouri 64111.

for Henry Miller

Introduction

From a land steeped in history and mystery comes one of the finest and most revered breeds of man's best friend. Named after the rugged and remote eastern Canadian province, Newfoundlands are famous around the world for their countless reported heroic sea rescues of men, women, and children whose ships foundered on the storm-driven and dangerous Newfoundland coast.

Theirs is a story of unfailing strength and bravery, unswerving loyalty and determination, and a mutual respect and friendship for man, especially when in peril. History documents the countless lives saved, but none can capture the feeling upon seeing a big bearlike face paddling toward them in the teeth of a winter storm as this: "Above the wind that screeched like a thousand banshees through the shrouds we heard the death throes of our ship against the rocks. Though the cliffs were less than a league away we prayed not for an angel to guide us through the boiling surf but the steadfast grip of a Newfy to take a line to shore."

Today the breed is as much prized as ever for its seafaring nature and love for companionship, virtues that shine through in this book that celebrates the incredible personality and human-kindness of the Newfoundland.

George and Hugo

When you're just a little duck

Swimming in a great big pond

Courage is sometimes hard to pluck

You need a friend, of whom you're fond.

Make sure he's big and strong to lend a hand

You can't do better than a Newfoundland.

Just sit snug upon his head

And while you will make quite a sight

You know everything will be all right.

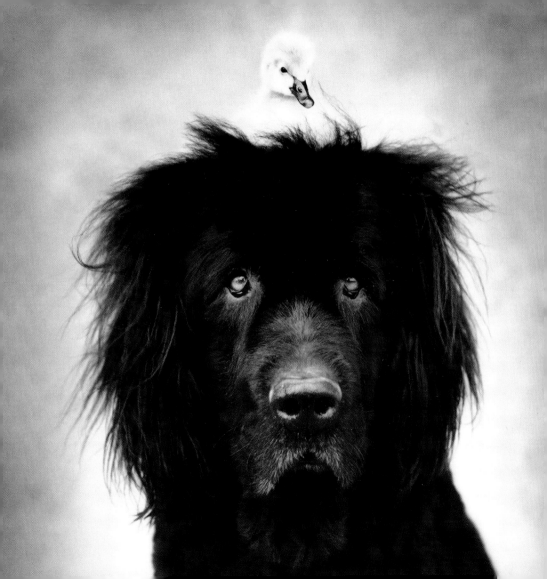

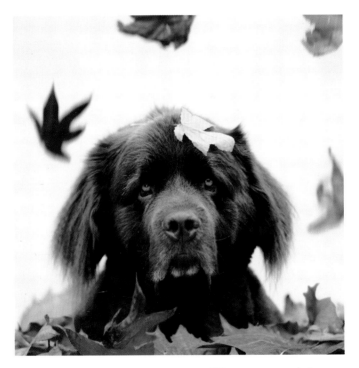

Autumn Henry

Ever noticed how your **dreams and thoughts**
can take you **anywhere** *at all*
and all in the time it takes an **autumn leaf** *to fall?*

Henry and Edmund

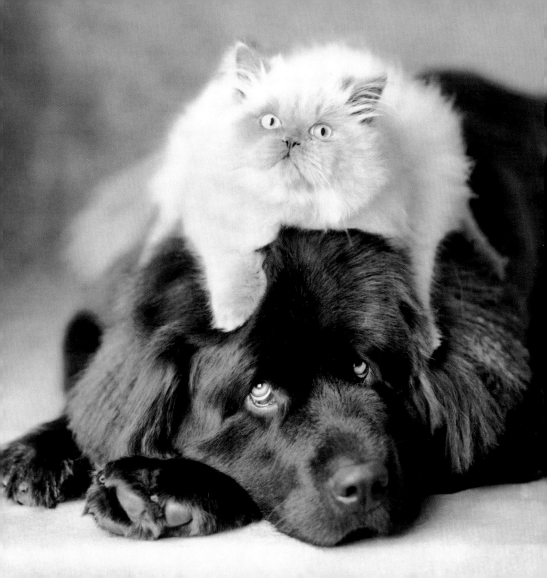

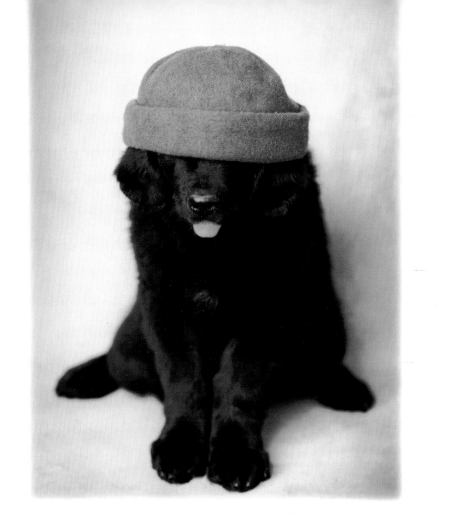

Oscar

Three months at sea on the fishing boats

suits old sea dogs like me in my all-weather coat.

The winters are tough, or so I'm told

I poke out my tongue to see if it's cold.

Fresh fish every day hauled from the sea

it is a life of luxury.

Every day excitement and adventures unfold

but what's best there's always fresh fish to fill my hold.

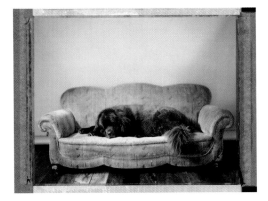 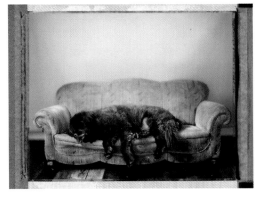

9 A.M. I P.M.

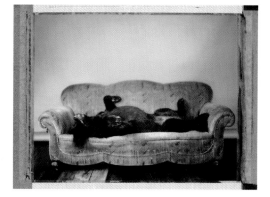

4 P.M.

A day in the life of Henry Miller . . .
Couch Potato

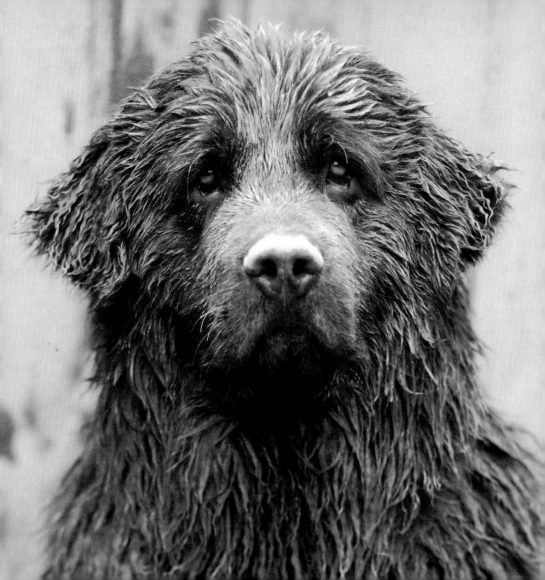

Mud Henry

What could be more heart-stopping to see

 than the sight of a massive brown bear

 loping through the wooded hillsides toward you?

Only one thing. The realization that it's a big friendly

 Newfoundland called Henry who's found

 a mud hole to play in and now is going to need

a full wash and groom before he goes to bed that night.

I've been there and I've done all that.

I've seen it all, that's a fact.

Don these goggles and this scarf

and come and fly in my backyard.

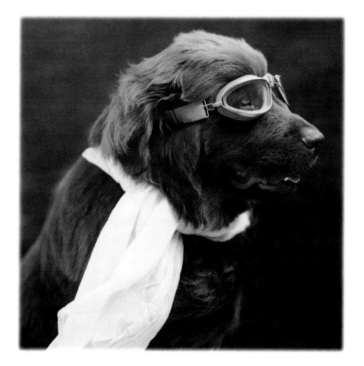

The Red Baron

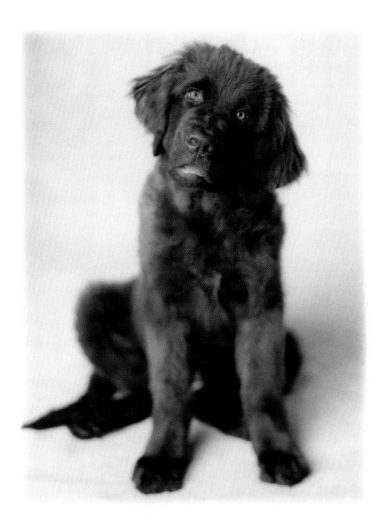

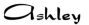

Corduroy

Casual, comfortable Corduroy
 Wherever he lays his hat is home.

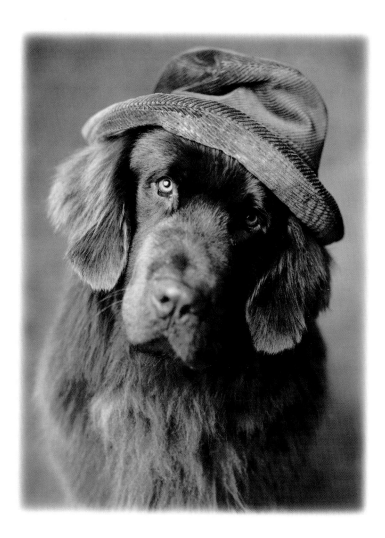

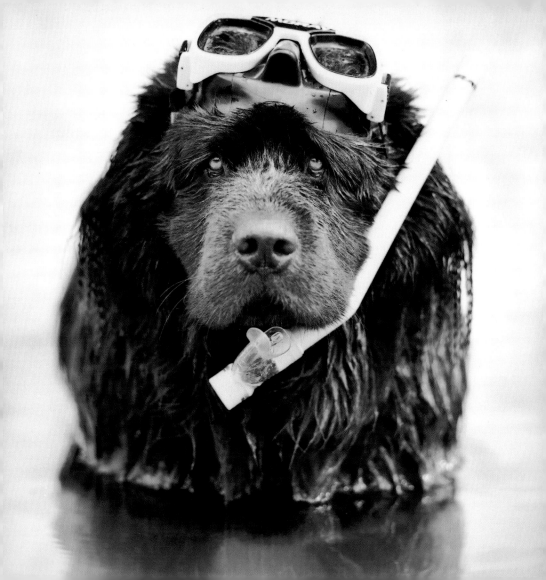

Henry Swimming

It's always wise to have a diving buddy.

 Someone who shares your respect for the sea.

 It also helps if you've only got one wetsuit and one towel

Because this guy doesn't need any.

 But just beware when you're high and dry

 And he's standing on the beach nearby

 That when he decides to shake his hair

 Make sure you're standing well clear.

Henry and George

Two of a kind, one of a pair

Christmastime is the season to share.

But know their presence heralds trouble

when they try to join in the Christmas Carols.

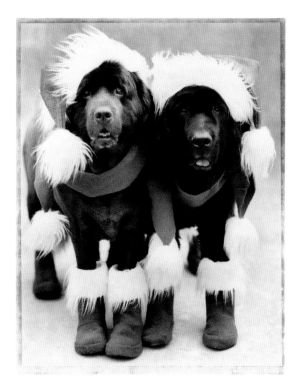

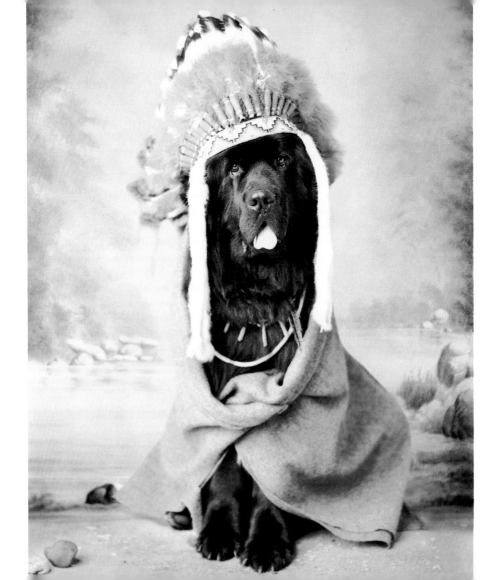

Little Bear

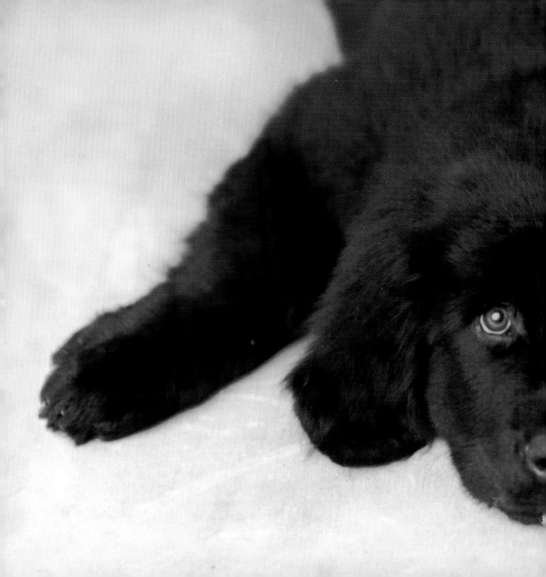

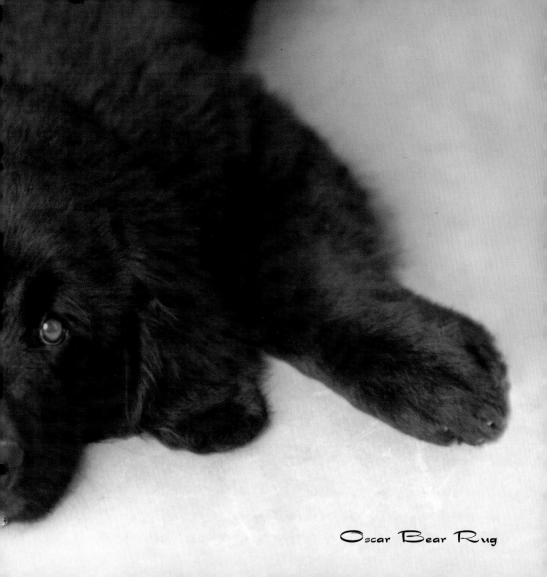

Oscar Bear Rug

Ashley and Bears

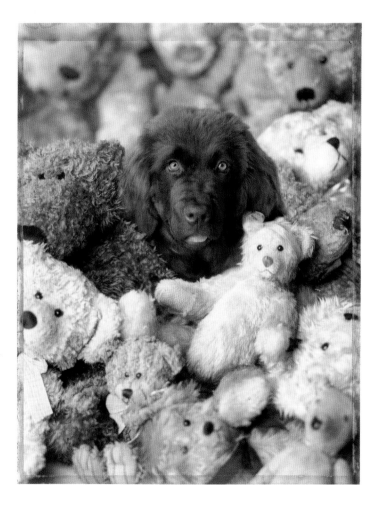

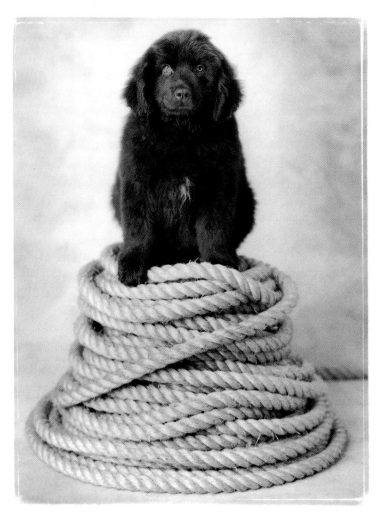

Henry Miller

Life *is* sometimes *like a* tight rope.

Grandma Storm

Who says you can't teach an old dog new tricks?

Old Gran'ma learned to knit.

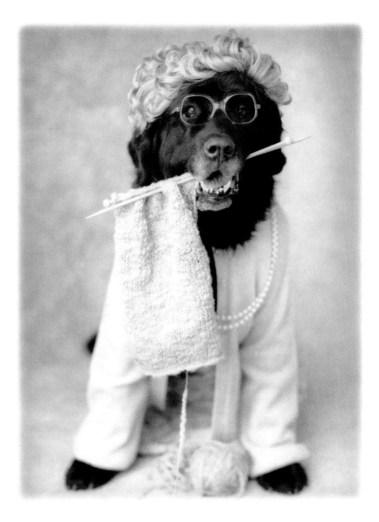

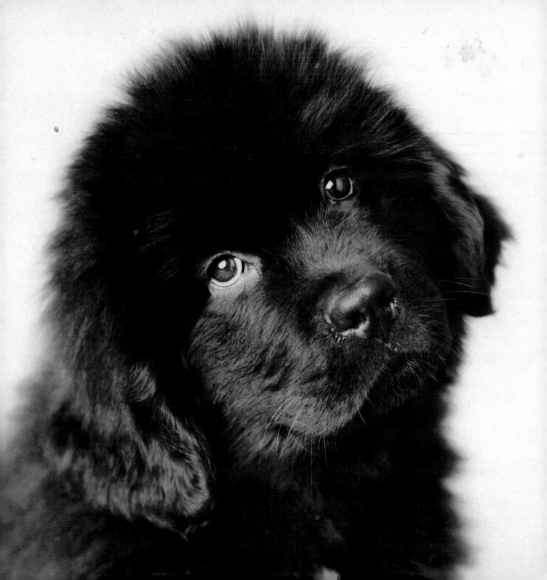

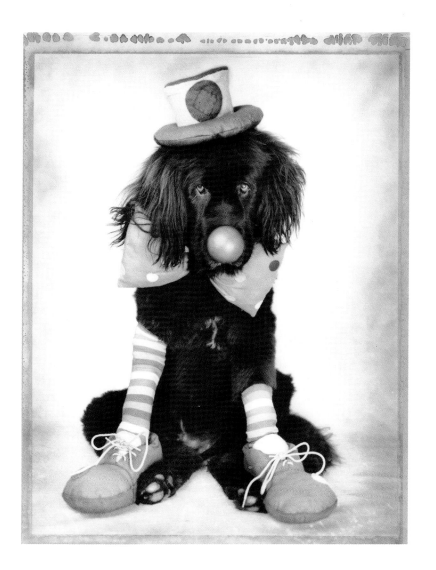

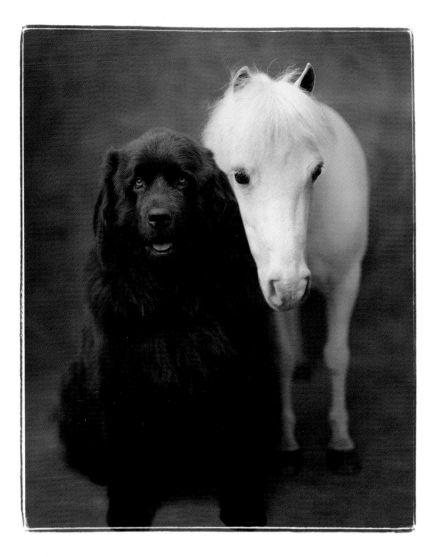

Henry and Geronimo

Henry and Pipi

Henry knows the drill.

He understands that he has to keep quite still

because if he should move even by an inch

old Pipi, well . . . her claws will clench!

That would leave everyone in the lurch

which is why Henry's such a faithful perch.

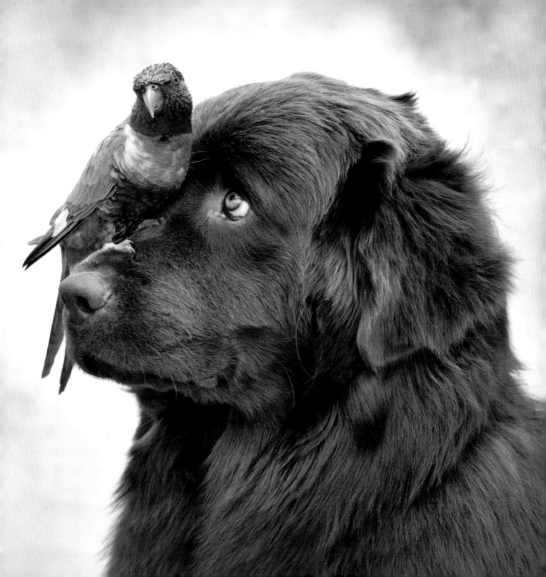

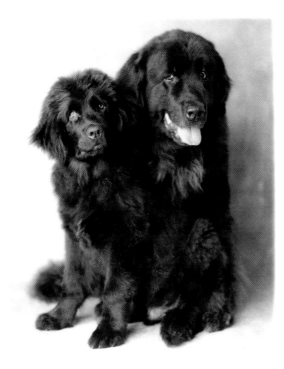

Henry and Woody

Wide-eyed and bushy tailed

the younger Henry has always looked up to Woody.

Certainly as his mentor,

he's taught him everything he knows.

But when it comes to presiding over his young protégé,

Woody displays a casual air

of all care but no responsibility.

Every dog has a secret
that he tries to keep under his hat.

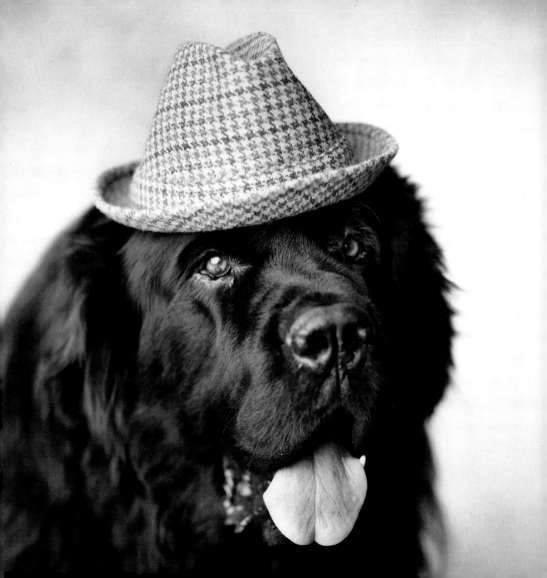

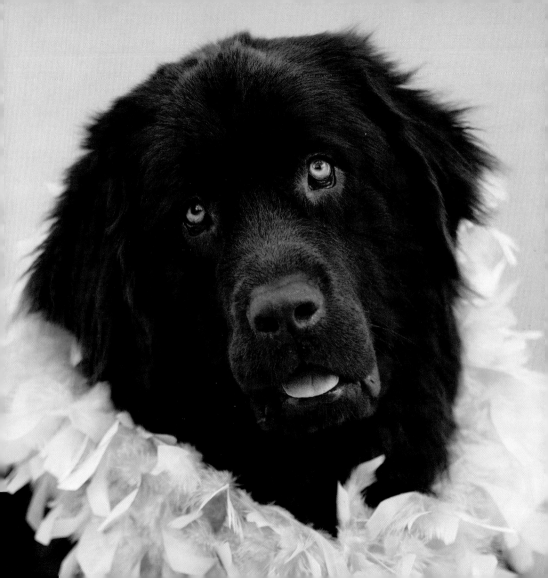

Coco

When your absence thrusts you into my mind

 I wrap myself in something you left behind.

 Your fragrance guides me like a star

 To think of you where ever you are.

 I'll stand vigil for you while you're away—

Till the moment your car pulls into the driveway.

Henry and Bradley

Gentle giant, good strong friend

he'll stand you in good stead.

Living legend, gallant hero

of stormy coasts the sailors feared.

Loyalty and trust come first

the best of any breed.

And knowing that he wouldn't harm

a hare on anyone's head.

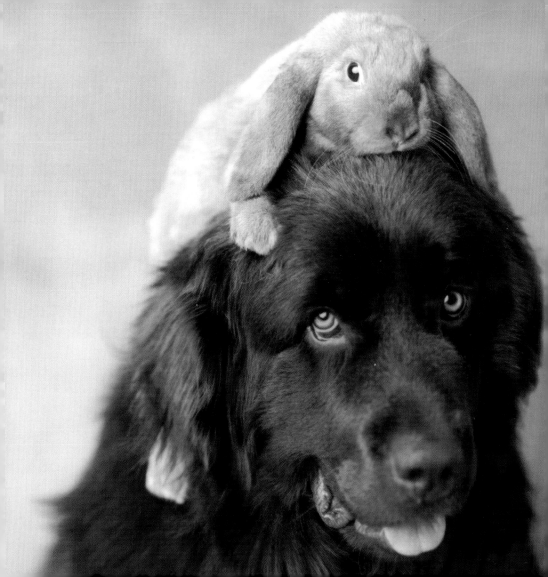

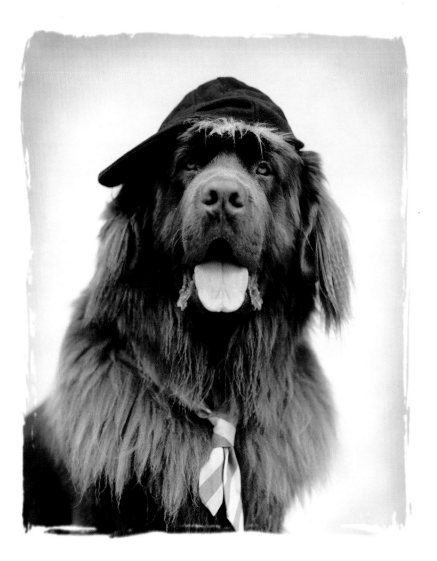

\bigcircscar

Doggy school's out, it's time to play

Now I can do everything my way!

Bear and Jordan

There are some things that only *brothers* share

Special memories and kinship unique to them.

For the older brother, a *friend and ally* for all the mischief you're up to.

For the younger brother, *following in footsteps* that one day you'll fill.

Together, you always look out for each other.

Because *younger or older he's always your brother.*

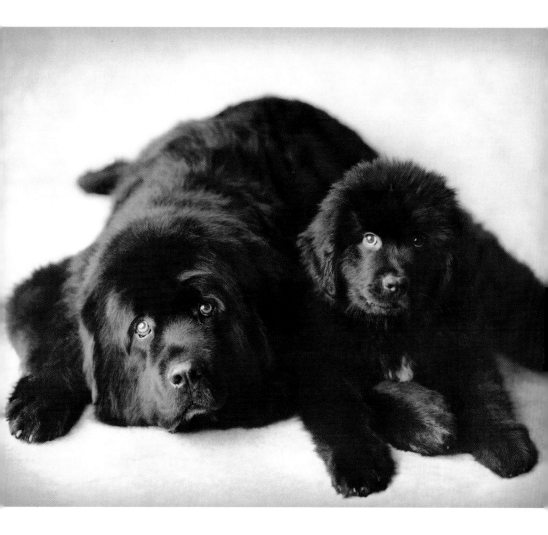

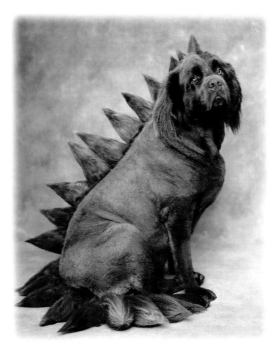

Henasaurus

Friends come in all
shapes and sizes!

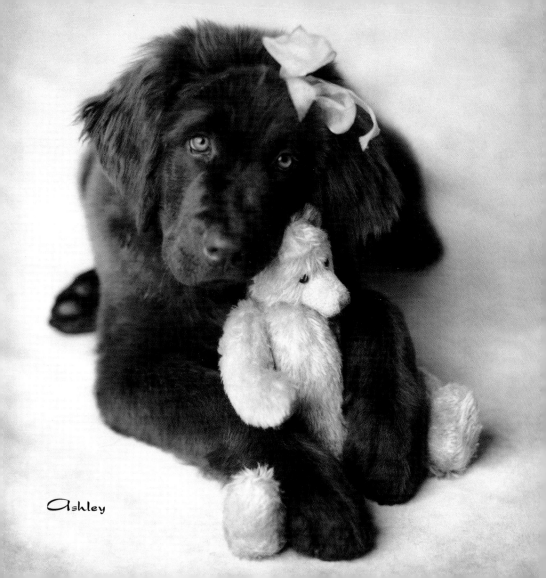

Ashley

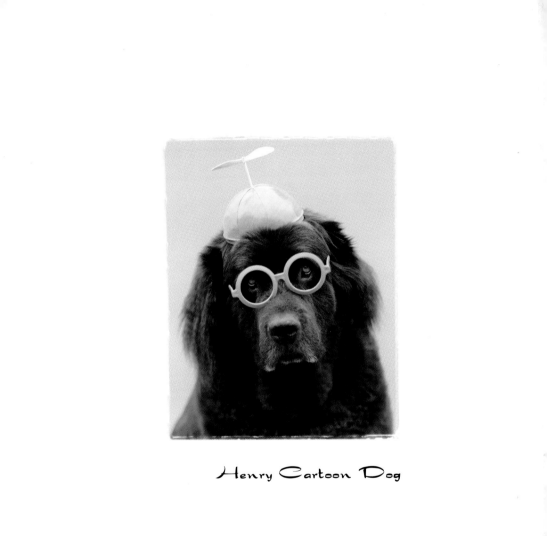

Henry Cartoon Dog